horrible intimacies

Previous Titles by Geoff Peterson

Cordes Junction
Medicine Dog
hecho en Mexico
Bad Trades
Cold Reading
Crazy Stairs
Drama & Desire
The Greyhound Bardo
Cine Bahia: The Suicide Codex
Fiery Messengers
She Dropped Me in the Middle of Nowhere & other poems
Dark is my Therapy
Tucumcari (with Megan Collins)
The Perry Square Gospels
Penance
punto: poems with time running out

Titles available at Authorhouse.com, Amazon.com, Barnes&Noble.com or through your local bookseller.

horrible intimacies

geoff peterson

AuthorHouse™ LLC
1663 Liberty Drive
Bloomington, IN 47403
www.authorhouse.com
Phone: 1-800-839-8640

© 2014 geoff peterson. All rights reserved.

No part of this book may be reproduced, stored in a retrieval system, or transmitted by any means without the written permission of the author.

Published by AuthorHouse 07/03/2014

ISBN: 978-1-4969-2296-0 (sc)
ISBN: 978-1-4969-2297-7 (e)

Any people depicted in stock imagery provided by Thinkstock are models, and such images are being used for illustrative purposes only.
Certain stock imagery © Thinkstock.

This book is printed on acid-free paper.

Because of the dynamic nature of the Internet, any web addresses or links contained in this book may have changed since publication and may no longer be valid. The views expressed in this work are solely those of the author and do not necessarily reflect the views of the publisher, and the publisher hereby disclaims any responsibility for them.

Photo credits: © geoff peterson: Old Ft. Lowell Adobe, Tucson, 2013

I dedicate this work
to Douglas Leichter
artist-in-residence

Acknowledgments…

My heartfelt appreciation to Dr. & Mrs. Steven Joseph of Tucson & Alameda for their insightful series of discussions of the Torah; to Dr. Daniel Asia, composer, and his wife Carolee, for inviting me to their Passover Seder; and to poet-novelist Paul Pines and his wife Carol for the embrace of their society.

My thanks to Rebecca Noel for her interest in my work; to Rob Nilsson for his films and books; to my daughters, Cassie & Cornelia, for their latest bold steps forward; and to all in my family, living & dead. And, always, to "Megansky" who continues to inspire by laying track one step ahead of me.

On a sleepless night, in compliance with prophecy, a voice says to a man in his sixth decade that

anything issued from inside you that is less than resolute is an insult to yourself.

The clothes are being ripped off the old system. Just before dying, it is showing its horrible intimacies.

—Lorenzo Meyer

Introduction: beginner mind

I must've signed up for a psychic weekend in the desert, and am assigned an exercise where I write down what brought me here in the first place. I'm instructed not to share my notes with anybody, as spirit mediums must first interpret my text. My notes contain the words YECH (or a final K), and MEH. I've written that I had barely enough stamina to drag myself here. The mediums in attendance project upon a screen my two words in caps and begin shifting them to different places in a sentence. It is during this process that I slowly begin to lose my sense of confinement in this life. I see that I had fallen into a trap of people, places & things, and mistaking the pattern of those things for my life.

In another room I spot a basketball and a kid's miniature hoop, and announce that the fear of shooting baskets is that, despite taking your best shot, you still miss. Which is what I proceed to do—7 shots, all misses, and I laugh as it gets cosmic in its implications. Then a tall, comely woman grabs a rebound and starts making absurd shots. She plays for a team of Quakers or Mormons or Baha'i, she says, and tours internationally. Then we sit down to eat and regard everyone with effusive psychic energy.

I wake up a changed man. I see that I have cramped my understanding and called it aging or dying. I have ceased answering invitations. If I'd just pick up a phone or cross the hall to the person waiting, things would perk up in a scary new way. I'm sure I had to meet you and write this book before I could have this dream. Books are written in order to wake up elsewhere, aren't they?

G.P.
2014

book done/Margot gone
effective this morning:
what do I do now

our kiss in the cafe lot
before taking the freeway
still fresh—

who will fix my eggs
brew deep coffee
& retrieve lost files

who will love me
& count the minutes
till we touch?

and Max thought he
the only ghost in residence
at our complex

she said she'll call when
she gets somewhere
drop me here I said

pop the levers on
the horn case and lay out
tools for cleaning

bore the bell's dinked
shaft, oil the valves:
reassemble

fire up my cold trumpet
and commence to blow
"St. James Infirmary"

the 1st piece learned off
the record the year
of my crack-up

hunkered on the edge
of the bed—nothing but
spit & air, air & spit

lips numb, jaw sore
& my chops rusty…
how much self-doubt

& scores of false starts
before a woman flees
and blues a cold storage

Max awakens
to a knock at the end
of the universe

but ignores it till I'm gone
and recalls a dream
speeding in a boat over
vast water with
a chainsaw

the point being
he can see straight
to the bottom

Max despairs:
so much undone and
nowhere to begin…
eat something, I said

Max hauls rough sketches
up the stairs —doodles
on napkins with coffee
& seeds from a bagel

existential angst—
if not, then what is left
but protocol says

the door mat at Max's
I knock and wait
for footsteps

I want it on record:
I'm against breast cancer
and abhor diabetes

are you in there?

when the door opens
I'm greeted by the odor
of questionable fish

handing him my book
I suggest he read it before
doing something rash

Max calls my work
bare to the bone:
just the facts, mam

fact: never would've met
the man had Margot
not vacated the complex

fact: that Max & I born
& raised separately
in post-war New York

unknown to the other
I an infant when my father
enrolled in classes

18 years later to study
acting I commenced to scout
rabid neighborhoods

Max by then snagged
by multi-headed dragons
spiraling downward

in a loft on the Bowery
while camped in Alphabet City
in a wrecked car—*moi*

the difference between
being a native he says
& slumming

in New York that winter
just off a Greyhound
with my annotated
Stanislavsky…
an inward creature
curled in parking ramps
with newspaper, a kid
for whom strangers did things
until they stopped

for forty years turning that
inside out—and now
facing outward find
delight offering Max
this latest edit

the start of a synthesis he says

Max asks how can he end his life
after his daughter's urging
to take cautious steps
forward: he

*intransigent husband & father
with a legacy in art...*
says the Times

of course mistakes &
grave miscalculations
were made—

*but is that not the point
of our search for the other*
imploring him not as
daughter to father but
beast to beast

 Max admits
when I insisted suicide's
an option that it
sobered him
 everyone says
don't even think it—
as it angered God
and left a mess for others

shutting the laptop
his daughter provided
I remind him today
is written but still
we wake up startled
by sirens

Max loaned me a book
by a friend with Max's painting
Quasar on the cover

reading the 1st entry
I recognized *terra incognita*
and told Max I'd sleep
on the poet's floor
to study the man's
process

as Max informed him he was
moved to welcome me
a brother—*hosanna*
my homeopathy, the long
corridor of wounds
reopened

hosanna a transmission of failure
whispered in print
in cities where poets
pay for copies
to send their families

hosanna my whole life
blooming in the desert
for no reason

I remind Max New York
was a 2nd job just
to rise, go forth, witness…
I could not keep up and
underline in books
at Stanley's on 12th &B
playing hooky

at the end life became simple:
on $10 I could drink or
visit MoMA, drink
or attend a lecture
at Cooper Union
I could drink or ask
Judy out and dare myself
to challenge the check

I could drink or
remain in the wings
awaiting my cue
and enter stealthily

after one month I stopped
attending class and
adopted Stanley's for
my eye-opener and
drank up my father's money

quoting texts for whiskey
I never got started
never used my chance but
camped in possibility

winter's subways
& an abscessed tooth
Max & I that year
agree we probably passed
each other: I of late
to Carnegie Hall, and he
the Art Students' League

he argues I'm not alone
I will move again and
do something useful
to the delight of others

my coming to the desert
a thorny blind path
of self-seeking

for Max a flight
from wrathful demons
with hopes of renewal

for both of us
an encounter with the other
& mutual possession

in raw pigment
our trials & suffering
the stuff of legend

witness the journey
of Gilgamesh to humanity
wandering in the desert

and I quote when
the beast rears up
and becomes my friend

Max obsesses over Isaac's
trauma in the Torah
at the hands of the father

spared sacrificial slaughter
but traumatized, the boy
grows up stunted in favor
of siblings and
rarely utters a word

forced by his own father's
affair with a Bronx neighbor
into divided loyalty
Max refers to *curses*
& blessings in the Torah—
blessings but a speck
in the cosmology
but curses—*sheesh!*
grotesqueries about
eating yr children—
don't get me started…

the seeds of conspiracy
sprout in the heart
of a stricken mother
go figure

some days my job requires
I surprise him with
how good he looks
after he's showered
shaved & repaired
his watchband

some days seeing him
startles like a silence
I've misplaced
since Margot

some days the art
he makes is as bright
as rebellion and
forever expanding

some days Lazarus
answers the door
wild with gnarled
spectacles

how often have I said
I cannot go on
as before when
nothing happened
but myself

on our joint trip
to the mega-market
Max complains of politics
and the glut of cars
convulsed with base tone

tom-toms & smoke signals
to conjure the menace
of war councils in
Technicolor starring
Jeff Chandler

or unchecked reproduction
of genes regarding
the commodification
of fetuses

I purchase a single roll
of toilet paper
6 eggs not a dozen…

1 Gala apple 1lemon
& a frozen slab of flounder
for my supper

you sure you're not
a Jew he asks
quoting dietary
habits prescribed
in Leviticus…
until a therapist suggested
he stock up for his next breakdown

slamming beans on a pie plate
in honor of being hungry—
hunger begins
in dreams, as in life and
the footsteps of fathers

I recall the kid on the park bench
in Washington Square with
a blanket over his head
shat on by pigeons—

recalling my young father
sweaty with malaria
from the Pacific
hunched by the fountain
devouring his weekly
pastrami on rye

inheritor of the holy ones
&1st born of the dead
proclaimed as long
on promise but
short of breath…

just as we reach the age
when we must shave
like our fathers it's
time to die or
join the army
for no better reason
than to change

Max makes the rounds
in a desert place, slow mending
uncharted, unwilling
each breath a replica of
unpublished trauma

two great questions
facing every man: *who am I
and what am I going to do
without tobacco*

terrors of the economy
on a fixed income—
I can't even bag groceries
he says, at 67
cutting out coupons

I need not remind him
the world has pushed us
as far as it can—*it's
happened before:*
swept up by death and
replaced by others
the great mystery

Max, undressed, unshaven
the *mezuzah* at the door
last touched by a man
since dead, asks
what day is it

Max has not begun
a large canvas in a year
and cannot help but endure
wounds of old cruelties
against the self

dread, longing, panic
the same disquiet found…
what have I left out—envy
& perfection a demand
to be noticed

the call of an unqualified life
our wretchedness—
constipated, ghostly…
les malades he calls it
after poets who know
the delicate balance
of failure and
our going forth

paint that I urged
the rage held out
against God, yourself

Max reports yesterday
he donned his paint sweats
and entered the studio feeling
so weak & lightheaded
from barbiturates that
he stripped and fell
into bed

call day one a success

next he'll recall his youth
when what you wore
changed everything
as he was a tough guy
in the Bronx because
you had to be

tough guy, at 67, wearing it
makes him shudder:
it's hard to imagine—
me, once tough

his last costume a Roman
collar & black coat
dispensing his gospel
to pigeons

at the museum I bought
a copy of the photograph
of the first ship to bring
displaced Jews to America

observe their faces
in the bow of the *Marine Flasher*:
men, women, all of them
young, many waving—
the others unsure, all
craning to impose
hope on the future
before being ordered
onto trains for
re-routing

and the crowd at the pier:
rabbi, husbands
& wives in suits
waving as one to savor
the shock of entry

how long will I weep
recalling the procession
of Victory ships past
Hell Gate where

Mother held me
and gazed toward Manhattan
where untested actors
auditioned for *Streetcar*
and the audience for
Willy Loman's demise
wept, unable to recover…

where Bird held court
nightly at the Deuces
and de Kooning began
painting women…

I'll sign and give it
to Max as its meaning
will strengthen his heart

look at you he says
you take care of yourself
you run you swim
& ride a bicycle…
a book coming out
& another in the works
you're educated
you have a girlfriend &
2 comely daughters
your apartment the home
of a sane person…

I remind him how
the desert attracts men
who plan their suicides
and admit to owning
enough books to grossly
impede travel

Max understands I need
to say that to make
what's been said
reasonable

two lost souls
caught in barbed wire
he calls us

Max argues nobody's reliable
in the postmodern era:
*if you'll meet me
for coffee be there—
not 20 minutes after*

I agree but point out
that everyone here
came to escape a crushing
case of obligation
& urgency that starts
with family and
ingested personal indignity

you can understand how
loyalty's been used
to wound us, its legacy
stunting our growth so that
we ran for our lives

being artists we said—
our way of clearing customs
now look at us

watching the video
we consider the raucous scene
of Busby Berkeley's
breakdown, the chorus
be-gowned & stroking
pale violins…

Dick Powell crooning to
a perky Miss Blondell
you're so responsible—
imagine

Max narrating Sam Goldwyn's
trek across Russia
to get here: *one tough*
Jew after citing
the studios caving in
to McCarthy

cut to an overhead shot
of the entire history
of our peoples
cracking peanuts
at the Ninth Circle
on Tenth St.

Maxwell insists
he'll take it from here
and performs *shtick*
from every Marx Brothers
romp in the canon

Max's fractured sense
of origin compounded
by New York's make-over
via wrecking ball…
Moishe's downtown
grocer of his youth
to become a Viet
restaurant and later
a Chiliburger

chewing gum a nickel
& pats on the head
from gangsters…
all gone, dead, his friends
in art, film & society
murdered or by acts
self-imposed
their photos & captions
embalmed in texts

after so much doubt he
wonders who is it
that survives and
for what

it was easy being Picasso
in Paris, said an artist
but imagine Picasso
in Kansas City

exactly what it's like
being Max in Arizona
since the first decade
of a blasé century

enough to revive
the bad taste in yr mouth
left from the word
millennium

Picasso feared any water
he could not stand in
sd Max despondent, unable
to move back or

revive lost glory—
not glory, he objects
but the simple fact
of respect

let me suggest we meditate
and discover the root
of our attachment to
negative streams of thinking
and break free perhaps
of old assumptions
about who we are

but Max has tried that and
cannot suffer the tincture
of religiosity, besides
physical pain forces him
to consider time left
and scrambles the order
of events like a child
ruining a puzzle

Max contends
nothing keeps us vertical
like a cashier's smile
at check-outs

and how do you measure
success as a pitcher
but say to the hitter
I'm not going
anywhere

conveying my country's
unquenchable thirst
for bloodbath and
the mural of souls
slashed from the calendar
corporate juggernauts
a death defying leap
into *shock & awe...*

I declare if al-Qaida had
a listed number I'd
sign up so help me

Max calls it my *danse macabre*
and if given the balance
of biophilia & thanatos
guarantees I'd live
without strings

how do you know that?
our friendship he says
and everything he's told me
reading my mind

I am speaking in myth
I remind him

on the 14th day our conversation came
to make sense: *of course
paint naked* I told him
it works for me

Max skeptical after years painting
descending rungs of madness
while a model with a habit
sucked his cock on
Broome St—he can't
he said as the chill
forbade taking showers
in the light left over
from his Spanish period

his eyes fixed upon a point
of diminished returns:
art's not the point at which
we become interested
he says *but before
that, before that*

in answer to Max's painter's block
I advise long walks &
generous fucking

he argues the store's dark, shade
drawn & basement empty

marking our exit from a gallery
exhibit of photographs
by Charles Harbutt
I suggest Max take
ownership of late work
I mean how many singers
in Mexican bars
are cripples—
my *koan*

paint that I urge

Max doesn't find that
amusing and that's
the problem

preferring the company of ghosts
to writers I recognize
a bluesman right off

who regales us with legends
of Texas, staying alive
after a club owner shot him
for paying attention
to the missus, blackballing
the band from Midland
to Lubbock…

a player had to be *on
his toes and know which way
the wind blow*

fresh off the bus in '90
he bought a shack
at the foot of the Picachos
and took up golf

the poet's game, he laughs

50 years of Kennedy in Dallas'
open limo: a shutter second
when he looks into Jacqueline's
face with tenderness
and knows it's Dealey Plaza
and raining in real time
as we're splashed
with static between
what remains & what
transpired…

conspiracy theories our choked
longing for catharsis—
if methadone had not been
available says Max
he would've died or
killed someone

a poet I know
stops by our table
to ask if I'm going straight
I'd introduce him but
confess I forget
when he breaks into
an angry recitation
of his latest opus
in quatrains composed
on a bus from one
emergency to another

bedrolls of verses
inside his head I explain
makes the man blush:
this is what is meant
by Ginsberg's phrase
published in heaven:
a willingness to write
for the holy purpose of
confessing to God

Max's diarrhea requires bananas—
today's & counting

I buy them by the discount bunch
and announce that
a Hollywood starlet
was found blue in a car
of overdose but
there's cause for speculation
since the autopsy shows
foul play involved

*blessings & curses, curses
& blessings* he muses
before asking if
the corpse was blue or
blue the make of car

what I'm trying to say—
a child you don't know
and never heard of
will capture headlines
for months and end
abruptly

another story to keep us
alive by the paid for
minute he gasps

rumblings of old gossip
as fate welling up
in his guts—
treatments for Hep C
& the mesh for his hernia
needing replaced…
dyspepsia, dehydration
& diarrhea with doses
of clap makes
painting in his own shit
practical

mortality & technology's
efficient exits: how
we end up, he says
in a room upstate
adjusting the antenna
or punching a cellfone
with guessed-at numbers

four days' rain and not
one step onto *Paseo Ajo*
I can't decide to take
the train to Los Angeles
& walk into the ocean
or stumble south
to Sonora in search of
my grandfather

on the anniversary of his death
how is it I am no longer
reachable, that I cannot
make myself turn or
be brought back

Max left a message to come
for something kosher—
I'll eat standing up
and confine my attention
to the man's books

Max quotes from Catullus
via translation by Pound
il maestro, I exclaim
at our outdoor table

Max lowers his eyes:
he harbored bitterness
toward Jews but
you already knew that

discoverer of *paradiso*
terrestro the year he died
in Rapallo...
I did not learn that
till college

at 24 and fresh from
stealing a car, I
nursed my beer at
Friendly's and pored
over Pound's Confucius
while waiting for a man's
wife to appear

soon I'd be the only man
in prison who'd read
The Cantos

the man has touched
abomination, but
in matters of art
Pound never erred
and his failure a tower

I still hear his voice
in the shaken trees
and confess to Max I am
a sucker for tragedy

[Pound] *still has bouts of*
tremendous energy...
reported of the man's
confinement, *but*
there are days [he's]...
pathologically tired

sounds like us.
fatigue deep as the grave
he wrote from a cage
near Pisa

Max congratulates me
as making friends with fascists
can't be easy

Max performs poems
from his vast estate
and concludes by stating
he vowed to not stoop
to hostage taking

I suggest that it's important
we sometimes break
our own rules

he complains that tech
start-ups have usurped
our language but
conducts our talks
with titles & snappy starts
from which we go on
about ourselves

Max announces if apocalypse
is real then the Mayans
got it right but
 what ends
perhaps is not life
in the *Book of Chilam Balam*
as framed by Jaguar
priests & movie stars
but by us, that is
who we are

the Golden Book of the Dead or the Secret of the Golden Pavilion or the Lotus in my Soup
says:

running low on this world **world**
is the good news if **realm**
you subscribe to
the theory there is
another

that states there is but **kingdom**
one world too many **bardo**
and ours the least
manifested

Max knows because **dimension**
a wise old lover who **chakra**
hadn't finished school
informed him

unburden yourself **universe**
of backward glances and
dead appointments
she urged meeting him
at a desert terminal
between flights

in church I watch a young
mother reach for her son
and he bury his head
in her pocket
 the codex says
a man without ritual
is a savage without
sincerity

goddess in tight jeans
& hoop earrings
dispense your protection
on ravaged children

to glimpse the raven coifed
beauty winking at
her tired husband
is homage to another god
leaping inside me:
mommy don't leave
mommy only
my forgetting you
makes me clean again

there must be a word
for a woman of
abundant glamour to
inspire song

the café called
Beyond the Grave has
bread & real butter

we gorge on Russian rye
at an outdoor table
slurp black coffee
and make stuff up to fit our thesis

I only listen to the ideas of
shipwrecked men says
Ortega y Gasset

or maybe it's Georgie Jessel
I forget, said Max
enjoying himself

I told Max before this day
is out he will be with me
in paradise and I don't
mean the cozy club
in Harlem

paradise has tree snakes
he warns, *they leap*
from limb to limb
and eat birds

gimme Harlem, he says

Max shows me photos
in Helen Levitt's book
In the Street of chalk
drawings & messages
as I said I wasn't
familiar with her
and he can't imagine
how I managed
to live those years
and miss her work
that's easy I said
I was drunk and
didn't look or
looking too hard
went blind and
crossing 14th St.
got run over by
another calling

Maxwell a 5-star general
of the Vietnam period
Maximilian, emperor, conducting
a French adventure in Mexico…
& Maximus of course
ahoy in Olson's
epic work…

Max answered to each
cultivating portfolios
appropriate to season
& critical reviews of
the frothy art scene
in lower Manhattan
during that period
called SoHo

no surprise then
his flight to the desert
after rents shot up
the towers struck
and the scene nostalgic:

art is dust
he growls rubbing his temples

of that tribe that loves books
we exchange signed copies
but barely read before
nodding off

Max blames the Xanax
for sleep, Valium
to seal the deal

but gets up nightly
to weep and spray for insects

I've seen the leaves in my life
curl inward—as they will
in yours, he says
citing my tender
feedings of birds and
the care & watering
of poems

paint that I urge
the same age as Max
and forsaken

how tiresome our rants on
rapacious traffic and
the extraction of raw
minerals for mass
consumption and
wars on our behalf

car manufacturers
and the drug & insurance
industries having created
the lives we've adopted
who we are anymore
depends little on what
we dream or learn
in a man's eyes

exhausted finally
we climb to our apartments
and play old recordings

Max calls to describe
last night's dream
below deck as an able
bodied seaman, but
unfamiliar with ship's
registry and its
unknown flag, begins
running up & down
frantic for a way out as
compartments blow
& flood before men
can scramble

with no escape hatch
open, he must gasp
and wake up

I suggest that
waking up's a birth trauma
sans vernix

but Max is less afraid
of dying than of
being born

just awakened
from an eagle snatching me
up by the thumbs

and lifted above
the ground I cannot
break free enough

and have risen too far
to be dropped, the fall
certain to kill me

my swift ascent above
sunset breathtaking
as cold creeps in

maybe I've entered
a zone where no one
calls or leaves a message

Max gulps painkillers
and anxiously pats
his chest for money

Woman #1

who lived under assumed
names while in & out
of love, health
permitting

never the mother
of children but
fiery muse to artists
of the spoken word collective

from his Bowery days
Max hailed a cab
to rescue her more
than once warning

this was the end
just before running off
into the desert to
paint the rain

Max on occasion admits
his problem at depth
is what he believes
versus faith

at the end of our session
his thoughts prefer
dining at home on
Spinoza

ever rational
in his investigations
in dreams a wall looms
up in his headlights

I urge that he
crash and get thrown
from the car before
starting over

Kabbalah self-taught
the man fiercely
a savant but
given to lapses

recognized as among
the *lamed vav,** friends
dare not let on as
it would destroy him

* the *lamed vav* or *vavnik* as explained: the 36 wise men the world at all times depends on, but as interesting is the numerical value of each glyph, says Max

tabernacle

in the rabbi's sketch of
the portable refuge
called *mishkan*
the ark protrudes
as a woman's breasts
to suggest a wonderful
nurturance

to rise from bed upon
opening our eyes
and bathe in light…
blessed are they
embalmed in apartments

see *mishkan* for spirit
of devotion or quiet
commitment to duty
such as the Levites' role
in lighting incense

or the rabbi's task
of instructing in Torah as
what God dreams:
when Adonai restores
the exiled of Zion
we shall be as those
who dream—
goes the translation

into infinite space do we
bore a secret cave
of masks hanging
in pitch darkness
that God might meet us
face to face

tabernacle II

the creation & destruction
of the universe is not
a preoccupation of
the infinite but its
awareness of self
says a rabbi

Moses in the inner
sanctum heard the Divine
murmuring to itself—
like sand or the swish
of serpents in the mind:
either God speaking
or a stroke, he thought
then left the chamber
stammering

as I play the horn strictly
by ear Max asks
if I've had lessons

Once maybe but only
later after I'd quit
struggling & drove
across salt flats
to a place called Lovelock

up late at the motel
I'd play riffs—
blue notes the color
of blood before bleeding

Once on the coast
a woman who played
for Gunther Schuller
was so pleased she
suggested *never mind
notes—play the spaces*

Once I figured I might
almost be invited
to play with others
on a whim

since Margot left
I'm asleep by midnight
or read twice-read stories

at 3 a.m. I'll wake up
for an hour and
rise to drink coffee

sitting in a big chair
I gaze at a tapestry
called the desert

for Max the same
is true but with pain so
centered it's everywhere

he can no longer read
without confusion
and watches late news

that tells him nobody knows
what he suffers and
could care less

Margot I am torn
between you and the desert
and grow weary of
your absence as
an outstanding loan

there is not time enough
to pretend with the lives
we've constructed

Max expects my health
to hold and advises
I save money

when will I learn that
my life is worthy
and that a Tibetan
monk appearing uptown—
back home is just another *schmuck*

how difficult life's terms
having lost his faith
but cognizant

the living god that
answered the night
my life flew apart with
tremendous force

that scoops up my days
and sets me shivering
before dawn

the thunder in our hearts
who is God the thirst
for depth

Max shrugs: easier
said than done but
adds that his soul
recalls a summons
to its source, in fact
strip away my habit
of loss and remind me
solitude's more than
a labor, but a holocaust

I am nothing
find me

most of our talks
go nowhere and
break into footnotes

I recognize the outcomes
inside a minute and
listen abstractly

notice the GIs at airports
wearing camouflage
fatigues & desert boots

not dress green uniforms
or khakis & cut shoes
but men at arms

that's the Pentagon
getting us accustomed
to storm troops among us

so when the time comes
to keep order in cities
no one will notice

these evenings on
a crowded city bus
with Russian women
who clean buildings
and share recipes
from villages that
no longer exist

when I express
curiosity they reply
that if I come wearing
only a hat & condom
they will fix me
delicacies for a king

of course I must have
that translated before
I understand why
they're laughing—
or is it to show off
their gold teeth

this is why I love
women, I tell Max:
their secret language
like flies on fruit…

Max refers me
to mounds of gold fillings
picked from the mouths
of corpses

old world discussions
about how long since
our last shit

its contents described
for volume, consistency
and the meals that produced it

why can't I shit
like a normal human being
my stab at catharsis

fetal on the floor
with fleet enema
forcing deep breaths
I count the hours
bent over while
Mother pierced me
with a hose

even as a child I knew
I'd make of it a poem
someday

for guys like Max
calamity fails to
destroy as it did when
we anguished over nothing

we cannot care with the same
concern but instead
spend our lives
approaching tedium

and refuse to pretend for
the benefit of the jury
refuse to play
make-nice

for guys like Max
coffee can never be
hot enough, calling
our waitress—*again, nuke it!*

the cheese Danish stale
and despite her apology
Max will play hell
getting a refund

with Margot the urge to run
together our mutual
lust for things
fugitive:

a couple in a dusty coup
driving fast through
corn in Indiana...

at the motel an early film
with Burt Lancaster, the sap
chasing Ava Gardner...
abandoned she sees
an empty room—
he sees God

a man craves a lost cause
come here he says
you're so fucked up
and lovely

flying late to meet Margot
at site designation
Tango to ask about
our chances and
the state of search

Kansas City's ballroom
& legendary broadcasts
of Count Basie and
a 1300 mile gloom
of back roads…

at the hotel I'll suggest
she call the airlines
as her neck alone
qualifies her for
membership miles

she'll meet men up
in first class and
hotels with gardens
a chardonnay in long stem
replenished

I have not the nerve
at my age to tell her
I am unable to bear
the weight of us
much longer

Max insists he's finished
as an artist and
awakens late

before a blank canvas
with the eyes of a heavyweight
staggered in late rounds

groping for the ropes
when the bell rings
and he's led down a hall

Cantico del Sol

at 5 this morning
my eardrums burst
and flood the circuits

afraid I've had
a stroke but remain calm
and listen to birds

*ha! Max called St. Francis
Frank like Sinatra
crooning cantos*

*is birdsong music he asks—
of course or color me
a Nazi*

I said if Francis wrote
the prayer they say he did
I'd suck my socks

after I get up to pee
I'll turn on Joan Crawford
establishing boundaries

I should call Max
but I'll bet he's just now
finding dream relief

with a corpulent woman
back from an afternoon
of shopping

one cannot will a poem
or a painting into
being says Max
regarding the inconstancy
of the muse and her
appointments

what is art
says my friend *but*
the will desiring itself

our dialogues about
what's left to say
in a post-literate era
and writing that, reading
that, forces me to admit
I've willed poems of late
afraid to find out
what happens if the store
runs out and I'm
abandoned on a planet
where I must shit
as advertised or
go blind

states of grace
include a teenage girl
on a swing set
in the dark while
Max grumbles about
painting & theory

or just this morning
a grounds keeper
shoveling gravel at
sunrise from a trench
below my window

tonight Ingrid Bergman
in *The Bells of St.
Mary's* breaks
into tears at
the bottom of the world:
the circumcision
of the heart says Max

I've never heard it said
that way but invite
its piercing

to make your bed
while remaining in it
the solution to this life

decrepitude, nausea
sneak through misery
like a fuse

wired to vast solitude
one step keener
than before, and baskets

of breaths to climb
stairs to your studio
or a neighbor's

for dinner and not be
alone entirely but
alone enough

to relax, the covers
pulled up & over
to harbor the dead

this is what is meant
by a life in art
I thought

Max complains
of voices from the pool
below his studio

I describe the young boy
& girl splashing
alone at twilight

*did you think you
beat me*, he asked
*because you didn't
I let you win in
fact I swam
underwater to you
I swam all the way
to you before we
even started…*

the story of my life
I marvel and Max
agrees for once

abstract expressionists
convened at the Cedar St.
Tavern while poets
met at the Lion's Head

and in his exuberance
to succeed as poet
& painter he drank
profanely at both

I blew it, he says

I remind him of what
is required of men
to find out about
themselves

and insist the Cedar St.
featured TV—*just
for the World Series and
title fights of course*

what makes the past so
tender in photographs
difficult to imagine—
if it's what we said
it was or the shadow
of something else

today making my bed
so that everything
can begin—

stop, Max begs of me
please stop now

Max says he'll tend my plants
while I'm gone—
my 3 days on a train
hard on any man
bound for winter

-10 in the East
Margot says bring a coat
as I won't have use
of her car and the bus
schedule iffy

I pack books and
chocolate with nuts inside
to ease the pain of being
until I decide to stop
stalling and go home
and unravel this
like a lost map
to unclaimed bodies

hiding in the toilet
at El Paso's train depot
I fix upon the echo
of voices in the hall
hawking tortillas and
tickets to insolent cities

nowhere to go
but to mention meeting
Sol who knows
Max by reputation
and who's westbound
to San Luis Obispo…

*among the 12 loveliest
cities* boasts a magazine—
featuring couples from
a family album

Sol observes there is
something ruthless about
being a man that
resists treatment

on the train he fails
to remember that he spoke
to me and that we have
unfinished business

celebrating the new year
hiking 3 miles home
from an airport shuttle
after a month back east
with Margot

3 miles without sound
but stars & the occasional
light from a party

then turn the corner
to the balcony's Chinese
lantern & potted plants
left out in haste

inside lay the mail
Max left on the table:
bills, ads, a Xmas card
to a stranger…

Yehuda Amichai's
poems and watercolors
of August Macke's
on the floor

not to mention the woman's
voice like mercury
in a text of Margot's:
*every day I cannot
get rid of you*

Jan. 2—fifty years ago
I stepped from a bus
at Port Authority
and got a room at the Y
to begin classes
at the studio

*a facturd for yr musical
enjoyment* after Max
cuts a loud one

the price of a bowel movement
in the current milieu
estimated high

Max reports history's ebb
& flow so that
movement is desultory

in spite of my training
I was assigned
missionary work
and accepted in lieu of
cash—chickens, goats
& a mess of fish

now I sit mapping drops
of paint on the man's
studio floor

it's how the conversation
started and how
the conversation stops

upon my return
from before I slept
late and swallowed pills

on the 2nd day I devoted
hours to silence and
a walk in the park

on the 3rd day I
remembered a trip
from the future when

even my dreams
tied up in fog
the same as before

as somewhere exists
without words, design
or color

where the ancients
ended up but
knew better

where weeks go by
before I'll see anyone or
answer the phone

the winter everyone dies
I float through rooms
trying to decode
a course of action
designed in sleep but
resolving nothing

the poetics of puncture:
whiteout, like the sky
erased with a gum
eraser that crumbles
on the page

regard the girl's eyelid
in *Un Chien Andalou*—
steady I caution
what good is there
to put a spotlight on it

Max removes the lid
from a pot of oatmeal
turned moldy

put a spotlight on that

celebrated beginnings
without arrival
entire days filled up
with notices of friends
on the brink without
income

*who is not prone to periods
of terror* asks Maxwell
dismissing my latest

always a subscriber
to the idea we are
bound for Gehenna
Max insists it takes time
and when we get there
we won't know

we must decide that
to die is to wake up or
rely upon sleep
to lead nowhere

Max suspects
there's a soul because
his heart's broken
but understands it's
a private matter

every step I take
toward redemption
I get lucky

for instance

last Sunday the young
niña at mass, a rose
with her red dress &
plastic shoes, who
ran a finger over
the lines of a hymnal
in time to the choir but
without comprehending
its printed text

her hair shiny like
her mother's and she has
her father's long stare…

Max says there you see
now you understand
why I paint

I never was successful
at fitting people
into my heart

thus I ran from cities
to the desert not ever
obeying the stars

the point is that
our longing infused
with light

falls upon itself
and our loneliness
exposed

Max suggests I call
Margot and offer
a deal

dearest M

I'm happy that you watched
The File on Thelma Jordan
on TV last night

I smile thinking of you
alone with yourself
doing what's natural
so that—

you glimpse the tenderest
depths of the dark, and I
invisible in the room
clasp my arm around you

like a holy card Jesus
and you, Margot, my
precious wandering soul

Max & I walk the circuit
4 times around
Palo Verde Park

and recall Chapultepec
that Miss West compared
to all the parks in Paris

Max says everything
gone before is on the tip
of his tongue

l'existence est incipience!
I assert in a goofy
French accent

which sets us off on Sartre's
existentialism and attacks
of nausea that

Max endures promptly
and we wonder why
we adore Camus

our desert, his desert
the same and suicide
the only question

Max requires courage
to rise each morning
to paint while I
cultivate sloth
waking at ten to sketch
my next outrage

nothing serves as well
as drifting between
dream state & notation
whereas his methodology
insists he appear at
the wall to squeeze
banded serpents
from his rings

failing to make heads
or tails of my scribbling
I argue it's having to
guess at the words that
yields the poem

Nicanor Parra
99 this month in Chile
*me retracto de todo
lo dicho*, his motto

I take back everything
said getting to this place
and not enough time
left to raise a cat

my *vaquero* wife
had called this heading
for the barn, the ride
on the old plug's back
swift & tender

the desert's my need
to see long in all
directions said
Max abstracted

los viejos se mueren!
old people die, ha!
raves the border radio

Max reviews the men
his daughter's lived with
in set-ups as far flung
as Paris, Copenhagen
& Fez, her heart
that of a poet

the poem writes itself, I said
gazing at her picture
taken as a child
taped to the man's
refrigerator

a goddess without future
or fixing as I offer
to assist her search
for a family and
dedicate myself
ostensibly

the poem writes itself
but would never announce
to my friend I'll
ravish your daughter
but enter instead
into matters matrimonial
with consent and
ampleness of dowry

we study each other
as men across a table
to see who's kidding whom
when the poem runs out

Margot this evening
my yearning
is absolute

the doldrums of January
have crushed me

today the neighbor girl
finally moved away
and took her cat

after her boyfriend found
a job in California

Margot attends
to my father with
news I'm coming soon

it's you he wants
I urge, *enough in fact*
to pay you money

ignore if his toilet's flushed
he wants you —just
to run his eyes over

and recall when Irish
girls with battered trunks
arrived in boats

Margot as scullery maid
embraces fiercely and
respects privacy

reminds me of Typhoid
Mary quarantined where once
I was brought to live

why we play parts in stories
we thought ourselves
too good for

I explain to Max
nothing stirs my heart
as much as readers
underlining

not student highlighting
for tests but serious
underscoring to impress
islands in the mind

with notes in the margins
and symbols & arrows
like a treasure map
to the interior

Max says because
Treasure Island remains
my 1st book we are
bound as shipmates

as it's long been out of print
Max tracks it down
at a sub-surface library:
 Mal de Mer—
the best book ever
about tramp steamers

as a card carrying
seaman he should know—
that year steaming
to Borneo while
producing paintings
in the focsle for
his mother

*I hate books written
at desks*, he sneers
*give me books
grown in spurts that
twist & shout!*

recalls his opium dreams
and visions off
Jakarta where
all men are stowaways
with a mother dying

nothing watches but stars
as I enter the hotel
by the alley through
the delivery door
and search the halls
in milky green light
with the wallpaper
peeling & fallen bits
of alphabet…

past the kitchen's
huge steel pots on
hooks above tables
and urns for coffee
cold & shiny…
I glide up flights
of stairs and tug
on emergency doors
as if below decks
in a sunken ship
with bloated corpses
and debris…

Max listens intently
for my underwater dives
to find & bring up treasure

late rising we convene
to exchange monologues
of past journeys

rare angles of light
in Tunis and what they
foretold of marriage
& the break-up of matter

wreckage of the past
we call it, not just
our famous lists of
personal wounds but
battle scars performed
on dear friends

more dead than missing
and not to be Googled
as Max is afraid of
what he'd learn

I choose not to remind him
that nobody's gone—
just dead

Max can't help but notice:
how come we meet
at his place and
never mine

is it because I don't have
canvasses on my walls
or family photos or
objets trouvés

but crumpled pages
& a laptop stuck
on porn from Thailand
or Margot's relics

of affairs gone bust
no mistaking it for
the *Musee d'Orsay*
ne-ce pas?

Max wonders if I'm still
the boy who craves
being sent to his room
to play by himself

bloated with constipation
from anti-depressants
and pre-dawn binges
on Cheerios

snacks of prunes/applesauce
& coffee to get things
moving
 then flushed by
diarrhea, made
too weak to walk
till afternoon

Max calls to ask
how I'm doing
in barely a whisper

the same as you, I answer
and wonder when
that started

awake I put on coffee
then ravish Dame Margot
up in my head…

(since my return to the desert
we've mastered the art of
channeling hands)

after breakfast I'll work
till 2 then snap
photos of hawks and
1 of a blank wall
with the face of God
developing

I jog in the park
and watch a guy hold
service against nobody
then I swim a furious
20 before underlining
heresies in Dante

at dusk I fix myself
a cold plate & a pot
of tea before soaking
in a hot bath

I don't remember
anything after but
talk radio's going on
about aliens at the highest
levels of power

evenings on the balcony
the scent of take-out
from the corner
rapturous

completing my laps
I slip into a robe
as Gôrecki's 3rd Symphony
reminds me of an island
I called home

here it's January and
mild while desert birds
repair to Mexico

snowbirds in time-lapse
reading hometown papers
while Max upstairs
skypes his daughter
in Denmark to explain
that he's made a new friend
and it just makes sense

the last time with Margot
she dropped me at
the station and asked
for my nightmare:

curled on my grandmother's
couch I bolt upright
to a wild creature
in blazer & plaited skirt
lips gnarled & eyes
sparkling

who are you & what
do you want

it takes all my strength
to rise and push her
down to drive my point

her marbled flesh
scored with rot
& the eyes cratered

that's your mother said Margot
suggesting my investigations
among the dead are
over and nothing's
gained but trouble

we kissed goodbye and
I boarded the first
of many trains
heading west

in my desert tree house
are birds & flowers
& water streaming
into a pool

concerned with why
such peace frightens me
I watch myself trying
to believe I'm here
and tell Max

all I've dreamt of doing
is my work then swim
laps & go for walks
sans apology or
incrimination

stepping into moonlight I said
I am leaving this life
stalked by hallways
& taking medicine

Max intones that
I've entered the temple
of last things and
quotes scripture from
the dawn of the common era

this is why I've come
three thousand miles to
unhinge my heart

this once was a helluva town
I observe till New York
discovered it

really he says New Yorkers
there's not so many
yes but the few who are
are more fussy—
a point with which
he cannot argue

until later: *concerning*
what you said, why
are the local galleries
so putrid then

because only by humping in
the machinery of dross
can grace happen
look around, I argue
the whole country out
of work and everyone's
an artist—Matisse
with barcode:

art must be fun!

Max says he thought
I was supposed to help him
feel better

Margot our lives lived
in conjunction with
intense forms of transgender

as we both age and draw designs
upon the other, the end
not pretty, the end
stinks as stories go…

Margot writes I am
a sentient human being—
like it or not and

the fact that
we haven't understood
at depth makes us
perfect

Adam, Eve: Eve, Adam
the creation of a whole
other galaxy

December birth
the year of Hemingway's
gunshot wound
to the head:

Margot hatched
from the brain of Papa
though not fond of his work
for its disregard of
things feminine

but I love her because
she keeps me informed
of technology and
runs up mileage
 (we
get along, I sd
much better separated
by time zones)

and because she remembers
the bright afternoon—
Kennedy Shot
and the day she knew
it was time to stop
wishing and go home

let us not be defined by
our enemy says Max
lose your nemesis or
remain lost until
the stars fall

I've summoned mine
in this world who
wish me harm

and wonder often
what I can do
to hurt them or
make them sorry

what happens
to furious people at
the bottom of the pool
leaking bubbles

Max says steal
their women—who knows
where that can lead

but seldom does it come
to that and besides
survivors must always
be blamed he says
it's what it means
to be chosen

as for regrets where does one
begin, he mused

**I wish I'd finished things
I'd started**
—university
 —actor's training
 —military service
 —opportunities to travel
—relationships, the constellation
fathomless

Max says I'm too hard
on myself and argues
that I did in fact
finish those things—
only later

*the world has sold
its children but
you survived and
here you are*

since we both know that
we're always coming
into our bodies or
embarking to embrace
the fact we are alone—
we are all there is

I'm so tired, my friend
and I said we are all
tired, and he said
no I mean it

what is art but
to really mean it
I thought and how far
we've fallen

March the 25th...

Max began "mixing paint"
as they say to mean
standing before
bald canvas

unshaven, bloodshot
his clothes slashed
with color, the artist
has not slept but
3 hours in the 48
since Passover

and seeks medically prescribed
cannabis for relief
of migraine

you have to ask? he cries
waving his hand like
an impresario

in the opera of light
says a program at the Met
the burning from within
is our maestro

maybe Max keeps it up
for days or a week
without phone calls or
trips to the grocery

I've spotted a light on
in his studio through
the branches past
midnight

maybe he'll not be
fit to come out
until spring and
his strength spent

his spirit broken—
it's essential that
a true artist not
give a shit

viewing *Tosca* in HD
from the Metropolitan
we come to Mario's
aria in Act III

How the stars used to shine there
How sweet the earth smelled
The orchard gate would creak
and a footstep would gently
crease the sand…

God help me I squeeze
Margot's hand as if
she were here

Now my dream of love has
vanished forever and
I die hopeless…

Margot I confess
that for all the kids who
stepped off buses
in New York in winter
to study voice
I weep

for this I bow down
before you and
plunder my heart

Never have I loved life more!

last night falling
the patient suffered
contusions to the head
requiring stitches…

since being admitted
he attempts to shore up
his heart against
medical advice and
stands to urinate

I have brought him
a radio for the talk
shows & serious
music after midnight

and maybe an opera about
meeting a woman
underground who
tells us more than
we reckoned

Max finally sedated
when a squad of
white coats comes
poking for samples…
*there are 49 gates
of despair* he says:
take a number

in the dream I'm trying
to put a play together
and muster a cast
at a café during
a vacant year

how fateful to end up
alone as though
somebody else and
everyone disappointed

is that the definition of hell?

Margot says I'm still dreaming
so I must be sleeping—
who can be sure?
but if you ask me
I never sleep, in fact
no night's sleep
hits the spot like
it used to or as
shown on TV

if you have thoughts of
hurting yourself says
the phone message
call yr mother...

recalling the movement
of heaven & hell required
to skip town—to stop
mail delivery & newspaper
arrange for the flowers
to get water, the birds
fed, bills paid
appointments with
the allergist cancelled...

try taking off from this life

doctors, family, lovers
insurance specialists
of all description
arrayed in battle formation
to keep us vertical
alert, cheerful

the day we died we
were planning to make
important changes

I write to Margot that
her latest documentary
intrigues me

Max often raves about
a naturalist who spent years
with orangutans

spying them watch the sun
set over the Indian Ocean
tears in their eyes

revealing perhaps
a deep experience of frailty
as tenderness

dreams of the natural world
beckoning to us now
become insistent—

messages from rock, water
laments of ocean and
elegies of air

calling us in dream bodies
and thus I've adopted
Margot my oracle

as neither of us was a careerist
there was no water or light
to grow on

we could not bring ourselves
across the lobby to meet
the right person

now comes drought and the land
parched

Max says if we'd met
in another life, we'd
be mates on a tramp
steamer to Bali

celebrity invites
amnesia and the extinction
of curiosity but…

he says we need an audience
to guard against
the lure of auto-erotic
asphyxiation

he's trying to tell me
to resume submitting work
for appraisal after
decades of solitary

but I adore masturbatory art
I argue, *the roar of one
hand clapping*

he says of course we all do
rather it's a matter of
nuance

Maxwell I am still
running because I can
and come to meet you
so I can leave again—
let us embrace as
this life's lesson
is goodbye

I praise you for
your brilliant questions
asked of the rabbi
and for going silent when
the answers given
hung unchallenged over
darkness where
nothing glittered
but your pain

on the phone with Margot
about my poem under
construction that concerns
her fixation upon
a hypothetical key
to my room in
the desert that
lets her in to
touch me

people think we hole up
to write furiously—
we don't write poems
as such but scribble
on envelopes with
recipes to make
something else

like Maxwell with
his painting: apply
gesso and successive
coats to canvas:
a palimpsest

in truth all my work
an excuse to drink coffee—
that's the poem!

you're a fake she laughs
we all are!

finally our minutes spent
I advise Margot
to use said key and
let herself in

www.ingramcontent.com/pod-product-compliance
Lightning Source LLC
Chambersburg PA
CBHW030818180526
45163CB00003B/1343